The Vale of York Hoard

Gareth Williams and Barry Ager

THE BRITISH MUSEUM PRESS

First published in 2010 by
The British Museum Press
A division of The British Museum
Company Ltd
38 Russell Square,
London WC1B 3QQ

www.britishmuseum.org

A catalogue record for this book is
available from the British Library

ISBN 978-0-7141-1818-5

Designed by Esterson Associates
Typeset in Miller and
Akzidenz-Grotesque
Printed and bound in Spain by
Grafos S.A.

Maps by David Hoxley

Acknowledgements
Janet Ambers, Alexandra Baldwin,
Maickel van Bellegem, Hayley
Bullock, Amy Cooper, Dr Vesta
Sarkhosh Curtis, Stephen Dodd,
Professor James Graham-Campbell,
Dr Richard Hall, Marilyn Hockey,
Jamie Hood, Sarahi Naidorf,
Sue La Niece, Saul Peckham,
Fleur Shearman, John Sheehan,
Dr St John Simpson, Trevor
Springett, Professor Leslie Webster.

The papers used in this book are
natural, recyclable products made
from wood grown in well-managed
forests and other controlled sources.
The manufacturing processes
conform to the environmental
regulations of the country of origin.

Mixed Sources
Product group from well-managed
forests and other controlled sources
www.fsc.org Cert no. SGS-COC-005160
© 1996 Forest Stewardship Council

FSC

Contents

Introduction **5**

1 Unearthing the Vale of York Hoard **7**

2 The contents of the hoard **13**

3 The hoard in context **29**

4 The Vale of York Hoard and the unification of England **40**

Conclusion **46**

Further Reading and Picture Credits **48**

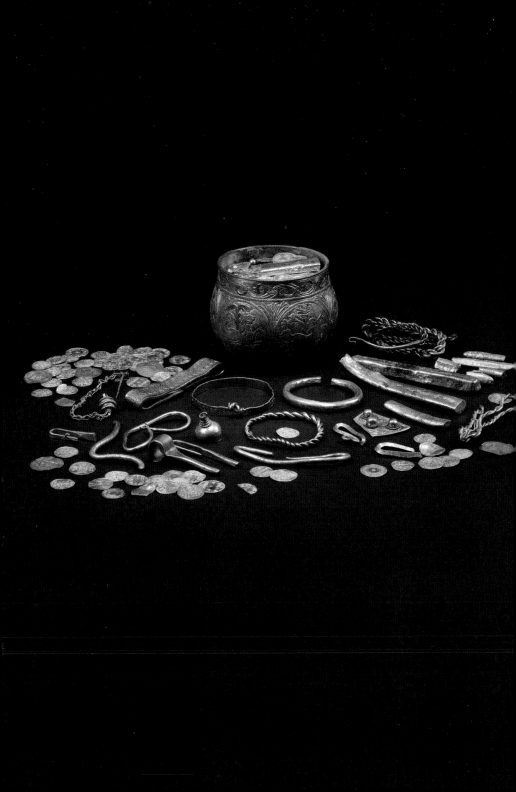

Introduction

On 6 January 2007 father and son David and Andrew Whelan were metal-detecting in a field a few miles from Harrogate in North Yorkshire. The two regularly went detecting as a hobby but, although they had made a number of interesting finds, they had never discovered anything major. By the end of the day the men realized that they had unearthed an important hoard of Viking silver (Fig. 1). Within a few weeks it was clear that this was the most important Viking hoard to be found in England in more than 150 years.

The bulk of the hoard was contained in a silver-gilt vessel dating from the ninth century, and careful excavation at the British Museum revealed its stunning contents. The hoard contained gold and silver arm-rings, chopped-up silver jewellery and silver ingots, and over six hundred coins. The coins and jewellery fragments came from places as far apart as Ireland and the Middle East, and the hoard as a whole reflects the amazing cultural diversity of the Viking world.

Unusually, it can also be dated fairly precisely. It was buried shortly after the West Saxon king Athelstan took control of the Viking kingdom of Northumbria in 927. This was a key moment in the process of the unification of England, and the hoard provides fascinating new information about this important period.

Unearthing the Vale of York Hoard

2 View of the River Nidd, near to the findspot of the Vale of York Hoard.

Discovery

The field in which David and Andrew Whelan made their remarkable discovery had previously produced nothing more exciting than Victorian buttons (Fig. 2). However, the other fields on which they regularly detected were under crops, and therefore could not be touched, while this field had been ploughed recently. Ploughing can bring deeply buried objects closer to the surface, so the men felt that it was worth revisiting the field. What David found first, around 45 cm deep, was a number of fragments of sheet lead, and a round object around 12 cm in diameter; his initial assumption was that he had found an old cistern and ballcock.

However, on looking more closely, David – a former dealer in coins and antiques – realized that the round object was covered in decoration, and that there were four loose coins on top. One of these was recognizable as a silver penny of the Anglo-Saxon ruler Edward the Elder (r. 899–924). Closer examination revealed that the round object was a decorated cup or bowl, and its weight made it clear that it contained something heavier than earth. David and Andrew carefully searched the immediate area, gathering up the fragments of lead that seemed to be associated with the cup, and discovered several other pieces of silver, all of which were too large to fit into the cup. The two also carefully noted where the find had been made, before refilling the whole.

Despite the obvious temptation to empty the cup to see what was inside, the finders showed great restraint. After consulting with a local coin specialist, they reported their find to Amy Cooper, the local Finds Liaison Officer with the Portable Antiquities Scheme, who in turn reported it to the local coroner as possible Treasure under the terms of the 1996 Treasure Act. Cooper was able to confirm that the Whelans appeared to have discovered a Viking hoard, with the loose fragments identified as pieces of silver bullion.

The hoard was then transported to the British Museum to be examined and excavated by specialists.

To make sure nothing was missed, the Whelans revisited the site with archaeologists from the York Archaeological Trust. They excavated the immediate area in which the hoard had been discovered, and carried out a geophysical survey of a wider area. However, neither the excavation nor the survey uncovered any features of Viking date that might have explained why the hoard was buried there.

Investigation

Once the hoard reached the British Museum, the first step was to X-ray the cup, to see whether this would give a clearer idea of its contents before the excavation began. X-rays revealed that the hoard was tightly packed with silver, and large numbers of individual coins were visible, together with several bulkier objects in the middle and towards the top (see Fig. 6).

The next step was to excavate the cup. This took a week, working through the contents in 1 cm layers. Fortunately the soil inside was light and sandy and, with a few exceptions, it was fairly straightforward to separate the contents (Fig. 3). The finders attended for part of the process, while British Museum curators were on hand to begin sorting and identifying the finds as they emerged.

Even with the X-rays, nobody predicted quite how much the cup would contain. Early medieval coins are very thin, and a surprising number can be packed into a tight space, as can small, compact pieces of silver. Altogether, including the four loose coins and the pieces of silver which were too large to fit into the cup, the hoard contained a gold arm-ring, 67 pieces of silver comprising 5 complete arm-rings and chopped-up fragments of brooches, ingots and rods, and 617 silver coins, in addition to the silver-gilt cup itself (Fig. 4). Initial cleaning was limited to making sure that each object could be clearly identified, and its condition checked. Once the cup was empty, it was X-rayed again, now revealing the intricacy of the metalwork, with six roundels, each containing an engraving of an animal, and a pattern of vine leaves around and above the roundels.

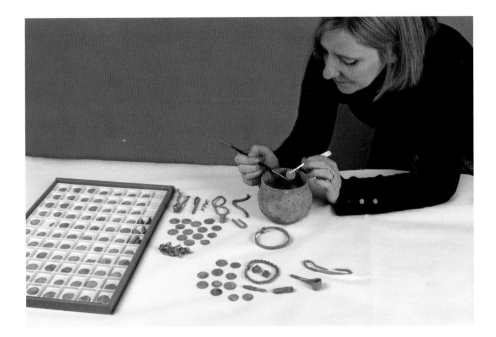

3 Hayley Bullock, a conservator at the British Museum, excavates the contents of the vessel.

Specialist curators carefully examined and catalogued each item in the hoard. A small number of pieces were analysed to establish that they met the ten per cent threshold of silver or gold set down in the Treasure Act, and a report was prepared for HM Coroner for North Yorkshire to consider. On 19 July 2007 the Vale of York Hoard was duly determined to be Treasure, and claimed by the Crown. The coroner's inquest attracted media attention from across the world, all of which picked up on the tremendous importance of the hoard. At this stage it was known as the Harrogate Area Hoard, but later was officially renamed, partly to avoid confusion with a well-known Bronze Age hoard from Harrogate.

Acquisition

Under the terms of the Treasure Act, the Crown only uses its right to claim Treasure if an appropriate museum (or museums) wishes to acquire the objects, and is in a position to pay a fair market price as compensation to the finders and landowners. Almost as soon as the hoard was found,

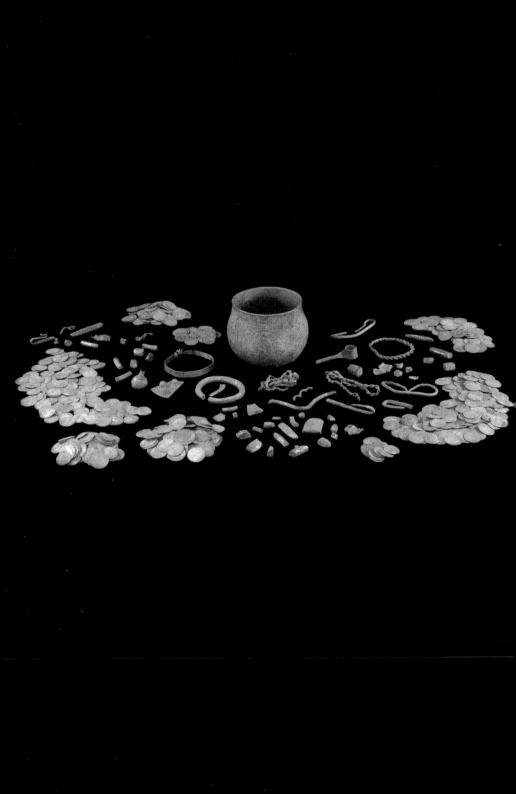

discussions began between the various museums with direct interests. By the time the coroner's inquest took place in July 2007, it had been agreed that the British Museum and York Museums Trust would seek to acquire the hoard jointly, with commitments to display the hoard at Harrogate as part of the package. Curators at the museums involved agreed that this arrangement would be the best way to recognize the significance of the hoard, from local to international level.

The next step was for the hoard to be valued. This was done by the Treasure Valuation Committee, an independent panel of experts which acts on behalf of the government in all Treasure cases. Provisional valuations were commissioned from a number of specialist dealers, and the interested parties were invited to comment on them. After a lengthy appeals process, the total value was eventually set at £1,082,800. This was a much greater sum than the British Museum and York Museums Trust could raise from their own resources, but the acquisition was supported with large contributions from the Art Fund, the National Heritage Memorial Fund and the British Museum Friends, with smaller grants and donations from several other organizations and a large number of individuals. The hoard was finally acquired in July 2009, and a team of conservators immediately began the long job of cleaning all the objects.

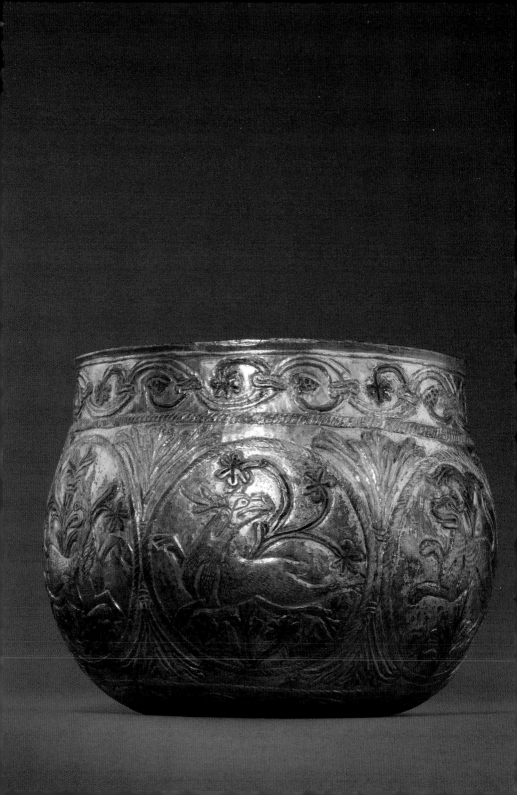

Chapter 2
The contents of the hoard

5 The Carolingian silver-gilt cup that contained most of the hoard. H. 9.2 cm, diam. 12 cm

Viking hoards are not uncommon, either in the British Isles or in the Viking homelands in Scandinavia. It is also fairly common for such hoards to contain a mixture of material, with intact jewellery combined with coins and silver bullion. What makes the Vale of York Hoard remarkable is partly its size, partly the range of its contents, and partly the quality and rarity of some of the individual pieces in it.

The fragments of lead found with the hoard suggest that the whole thing was buried in some kind of container that was made entirely of lead, or was perhaps lead-lined or had a lead lid. Most hoards are found without containers, since wood, leather and fabrics tend to rot in the ground, leaving no trace. However, lead survives rather better, and a number of Viking hoards from Britain have been found either in lead boxes or with fragments of lead, as in this case. Within this lead container there were a few large silver ingots, but all the smaller items were packed into a beautifully decorated silver-gilt cup (Fig. 5). This combination of an

6 X-radiograph of the cup before excavation of the contents, some of which can be seen in outline. The pin-like features are coins seen from the side.

inner and outer container has parallels with another Viking hoard of similar date, found only a few miles away at Goldsborough in North Yorkshire in 1859, which is said to have been stored in both a pot and a lead container.

Altogether, including the loose material, the hoard contained a gold arm-ring, 67 pieces of silver comprising 5 arm-rings and chopped-up fragments of brooches, ingots and rods (hack-silver), and 617 silver coins, in addition to the silver-gilt cup itself (Fig. 6). The container was by some way the most valuable item in the hoard.

The cup

The cup is 9.2 cm high, and has a diameter of 12 cm. It weighs 370.6 grams and is made of silver, with gilding both inside and out. Details of the design were enhanced with niello, an alloy used to inlay engraved metal, which shows dark against the golden background. The cup is decorated with six roundels, incised in low relief, each of which contains a single animal: a deer, a lion, a stag, a big cat, and perhaps an antelope and a horse. Each animal is shown running, with a tree or bush. The cats face forwards, and the other animals face backwards, with nervous expressions, so that the overall impression is of predators hunting in a forest. Above and below the roundels are two bands running all the way round the cup, and showing collared vine scrolls with grapes. The space between the roundels is filled with stylized leaves, again gathered together with collars. The roundels and the bands at top and bottom are bordered with a cable pattern. The decoration all appears to be engraved rather than stamped on to the metal. The cup is well preserved, and was probably undamaged when it went into the ground. There is a single large dent, around which is some cracking. This damage was apparently caused fairly recently by a plough while the hoard was still in the ground.

From the style of the decoration, the cup can be identified as Frankish workmanship of the mid-ninth century, probably from the northern part of the Carolingian empire. Altogether, seven other similar vessels are known, all from northern Europe and dating from the late eighth to mid-ninth centuries, although there are stylistic differences

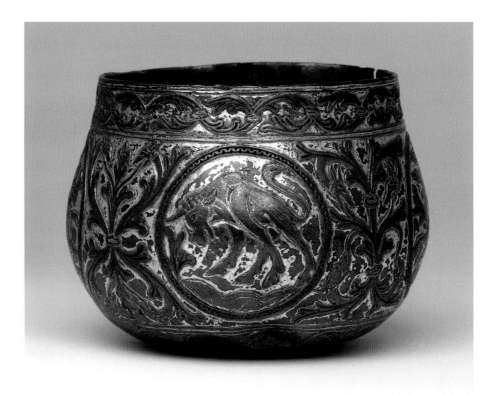

within the group. Like the Vale of York cup, some of the others have traces of internal gilding. One has a lid, and another similar lid survives without a corresponding vessel. The Vale of York cup may also originally have had a lid, although there is no trace of it in the hoard. The combination of lids and internal gilding has led to the suggestion that vessels of this type may have been intended for use in church services. One possibility is that the cup was a *ciborium*, used to hold the consecrated bread of the sacrament during mass, although since we do not know whether the Vale of York cup originally had a lid, it may have been used for some other purpose.

The Vale of York cup has particular similarities with two other vessels in the group, including one from Włocławek in Poland. However, by a surprising coincidence, the closest parallel comes from another English hoard, found at Halton

Moor in Lancashire in 1815, and now also in the British Museum (Fig. 7). The Halton Moor Hoard appears to have been buried around a century later than the Vale of York Hoard, in the mid- to late 1020s, since it contained coins from the middle of the reign of Cnut (r. 1016–35). However, the Halton Moor cup is so close in style to the Vale of York cup that it must date from the same period and was almost certainly produced in the same workshop, possibly even by the same craftsman. Not surprisingly, since it had remained in use for a century longer than the Vale of York cup, the Halton Moor cup was less well preserved when it was found.

There may be a deeper significance to the animal images incised on the Vale of York cup which has not yet been recognized (Fig. 8). The area between the roundels is filled with stylized foliage, and at the top and bottom of the cup are two bands, each of which contains vine scrolls, with bunches of grapes. The vine was a popular image in Christian art in the early Middle Ages, based on the idea of Christ as the True Vine. In a society with limited literacy, the use of visual imagery was a powerful means of conveying

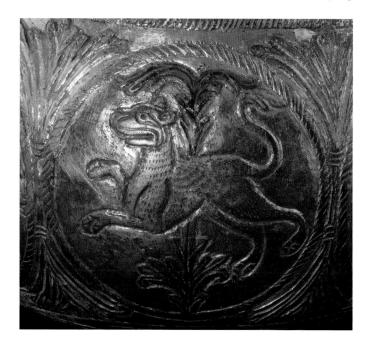

8 Detail of one of the roundels, showing a big cat, from the Vale of York cup.

a Christian message, and consciously Christian images are
common in the decorative art of the period. The animals on
the Halton Moor cup have been linked with a reference in
Psalm 22 and, although no significance has yet been
attached to the group of animals on the Vale of York cup,
they may also represent some kind of biblical reference.
Apart from specifically Christian interpretations, the
designs of the Halton Moor and Włocławek cups are thought
to reflect Oriental influence, possibly transferred to western
Europe through the medium of Byzantine textiles. In this
context it is interesting to note the striking similarity between
the cat and tree roundel of the Vale of York cup (Fig. 8) and
the lioness and tree design of a Sasanian (Persian) silver
dish in the Hermitage Museum in St Petersburg (Fig. 9).

Both the Halton Moor and Vale of York cups are Frankish
workmanship of the mid-ninth century, and it is likely that
their presence in Viking hoards in England is the result of
raiding in the northern Frankish Empire. The Frankish
kingdoms were often raided in the course of the ninth
century, particularly the area between the Rhine in the
north-east and the Loire in the west. Coastal trading
centres such as Dorestad were attacked repeatedly, and
even major cities such as Paris were sacked. Churches and
monasteries were often targeted because of their wealth.
The Vikings sometimes looted, but Frankish annals also
record several occasions on which the Vikings accepted
payment of tribute in precious metal in return for
withdrawing peacefully, or even for serving the Franks
against other Viking bands. Such payments were probably
largely made in coin, but items such as these cups may have
been used to make up the weight. Whether they were
plunder or tribute, the survival of the Vale of York cup into
the 920s, and the Halton Moor cup for a century after that,
shows that the Vikings saw them as treasured items in their
own right, not simply as a source of silver bullion.

The coins
Altogether, the Vale of York Hoard contained 617 coins. The
vast majority of these were silver pennies made in England,
but the hoard also contained four Frankish deniers and

fifteen Islamic dirhams. Several of this last group were fragmentary, and two of the Anglo-Saxon coins are cut halves, but most of the coins are intact and well preserved, having been protected in the ground by the silver cup. A few are slightly corroded, and others buckled, but these are the exception and it is clear that the latest coins in the hoard had circulated very little by the time it was buried.

Most of the coins are Anglo-Saxon. These fall into two groups. The first begins with the reign of Alfred the Great (r. 871–99) and continues into the reign of his son Edward the Elder (r. 899–924), and includes coins of Archbishop Plegmund of Canterbury as well as the two West Saxon kings (Fig. 10). Alfred's coins come from the later part of his reign, from around 880 onwards, and this group largely appears to stop in the middle of Edward's reign. Most of the coins are of Edward's Two-line type, which was issued throughout the reign, together with a few rarer types showing buildings and floral motifs, which are associated with Edward and his sister Æthelflæd extending their authority into the Midlands. However, although the hoard as a whole was buried in the late 920s, few coins from the later part of Edward's reign have yet been identified. This suggests that most of the Anglo-Saxon coins originally formed a separate hoard, perhaps ten to fifteen years earlier, which was then combined with more recent issues shortly before the hoard was buried.

The more recent coins fall into two groups. There are 106 coins of Edward's son Athelstan (r. 924–39). These include coins of the same Two-line type as the earlier issues of Alfred and Edward, as well as another common type showing a stylized royal bust. However, there are also some more interesting coins of Athelstan. These include a rare issue showing a building which has usually been identified as a church (see Fig. 27). Some of these building types carry the name of York, and are seen as the first issue after Athelstan gained control of that city in 927. Other coins of the type have been provisionally identified with the north Midlands, although they do not carry clear mint names. This type is normally quite rare, but the hoard contains several examples, all in excellent condition, suggesting that they had

not circulated for long before the hoard was buried. The hoard finishes with a single coin, which gives Athelstan the title 'King of all Britain' (see Fig. 27). This coin is central to the dating of the hoard, and is discussed further in Chapter 4.

The other English coins of the 920s were issued not by Anglo-Saxons but by Viking rulers in Yorkshire and the Midlands. These are a group of related types, all of which show a Viking sword as the main design. The largest group of these within the hoard was issued at York in the name of St Peter, the patron saint of York Minster. Interestingly, this coinage combines his name with a hammer, symbol of the Viking god Thor (Fig. 11). This association is perhaps best understood as a tool in the conversion process. Christianity has always been good at assimilating elements of other religions, and identifying Thor with St Peter linked one of the most popular Viking gods with a central figure of the Christian church. A related type was issued at Lincoln in the name of St Martin, and there is one example of such a coin in the hoard, together with two in the name of the Viking ruler Sihtric (r. 921–6; see Fig. 22). Sihtric ruled both in Northumbria and in the north Midlands, and it is likely that he was responsible for the Sword types on both sides of the Humber.

The hoard also contains an entirely new Sword type. This does not carry either Sihtric's name or a saint's name, but instead has a place-name, 'Rorivacastr', together with the name of the moneyer Otard, who issued the coin (see Fig. 22). This place-name is not otherwise recorded, but this is not particularly surprising as few Anglo-Saxon records concerning the north Midlands survive. The 'castr' element indicates a Roman fortification, and comparison with place-names elsewhere suggests that Rorivacastr represents an intermediate stage between the Latin name *Durobrivae castra* and the modern name Rocester, just north of Uttoxeter in Staffordshire. This part of Staffordshire and Derbyshire was the border zone between Anglo-Saxon and Viking England in the early tenth century, but the precise border is not well understood, so the new coin is important for our knowledge of the political situation in the 920s.

10 Silver pennies of Alfred the Great, London monogram type, *top*; Edward the Elder, Building type, *middle*; and Archbishop Plegmund of Canterbury, Two-line type, *bottom*

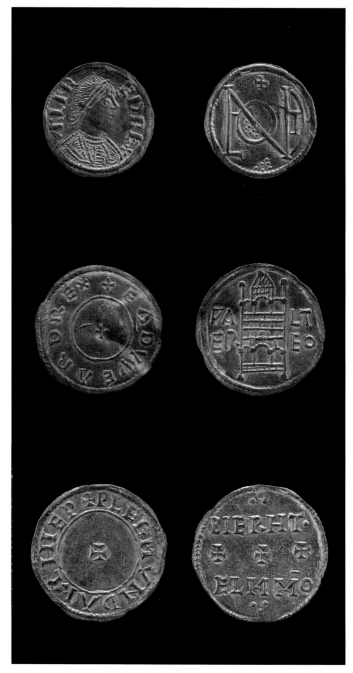

11 Viking silver penny in the name of St Peter, incorporating Thor's hammer motif, *top*; silver dirham of the Samanid ruler Isma'il b. Ahmed I, minted in Balkh in Afghanistan, *middle*; silver penny of the Frankish emperor Charles the Bald, minted at Quentovic, *bottom*

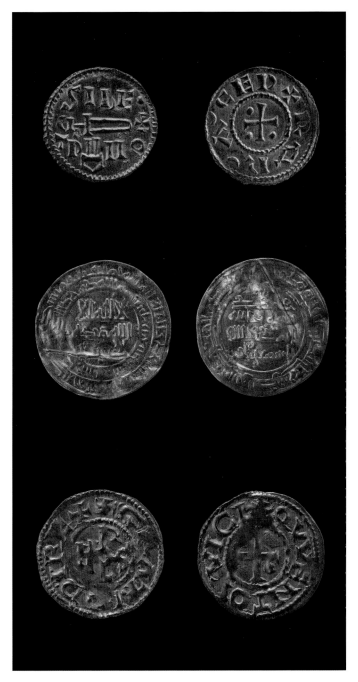

The hoard also contains four Carolingian deniers of the late ninth or early tenth century. The Carolingian kingdoms covered most of western Europe north of the Alps apart from Britain, Ireland and Scandinavia, although by the mid-ninth century the single empire of Charlemagne (r. 768–814) and Louis the Pious (r. 814–40) had begun to fragment into smaller kingdoms. All the coins come from the northern part of this area, with one from Cologne, in the kingdom of the Eastern Franks, and the others from Corbie and Quentovic (Fig. 11). Like the cup, these coins reflect Viking activity within the Frankish kingdoms, since such coins frequently appear in Viking hoards from the British Isles, but are extremely rare in Anglo-Saxon hoards. Even in Viking hoards they are rare by the 920s, suggesting that they had probably been in Viking hands for some years before the hoard was buried.

The final group of coins comes from even further away. These are Islamic dirhams, from the Middle East and Afghanistan (Fig. 11). A system of rivers through Russia and Ukraine provided trade routes connecting Scandinavia to the Black Sea and the Caspian Sea, and Arabic sources record trading between the Arabs and the *Rus*, the name they gave to the part-Scandinavian, part-Slavic peoples of the area. Islamic coins from the Viking Age are found in large numbers in Scandinavia; from there smaller numbers made their way further west to Britain and Ireland. Dirhams are larger and heavier than European coins of the period, and since the Vikings valued the silver by weight, rather than face value, they were often cut up or broken into smaller pieces. This is the case with most of the coins in the Vale of York Hoard. Dirhams and dirham fragments are found in a number of Viking hoards from England, including the one from Goldsborough, just a few miles from where the Vale of York Hoard was discovered. They are also found in archaeological excavations of Viking camps and settlements.

The jewellery

The Vale of York Hoard contained six complete pieces of jewellery, all of them arm-rings, one gold and the rest silver. The presence of a gold arm-ring in a silver hoard is particularly unusual. Because of its greater value, gold is in

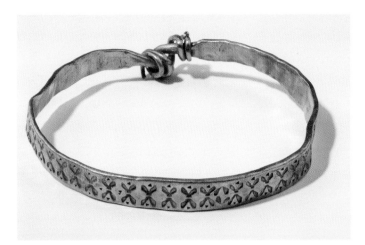

12 The gold arm-ring
from the Vale of York
Hoard. Diam. 7.5 cm
(max)

any case found more rarely than silver. When it is found, it is normally in the form of gold hoards, such as the great ninth-century hoard from Hoen in Norway, or the smaller hoard of four gold finger-rings from Stenness in Orkney, or as single finds. Other examples in silver hoards are known, such as one from Ballaquayle in the Isle of Man, buried around 970, but, like the cup, the gold arm-ring points to the great wealth of the owner of the Vale of York Hoard.

The gold arm-ring is a flat strip, decorated with rows of V-shaped punch-marks (Fig. 12). The ends taper to wires, twisted together to close the ring, which has a diameter of up to 7.5 cm, although it is now slightly distorted. Punch-marked jewellery is typically Viking, found both in Scandinavia and around the Irish Sea. This particular style with the twisted ends has parallels in both areas, notably in the famous hoard from Cuerdale in Lancashire, buried around 905–10 (see Fig. 18).

One of the silver arm-rings also has punch-marked decoration, but its shape is quite different, with a broad, thick band and with folded-in ends rather than twisted wires. It also has a greater variety of shapes in the punch-marks. Another silver ring represents a second fairly common Viking type with two wires twisted together, creating a spiral pattern (Fig. 13). Two others are simple rods with tapering ends that were probably designed to be

knotted together like the ends of the gold arm-ring, but which in both cases are now folded back on each other, perhaps having been adapted for a larger wrist. Examples of this type are also found in the Cuerdale Hoard.

The final arm-ring is a thick crude-looking rod with a circular section and plain ends (Fig. 20). Similar heavy rings are known from Norway and from Viking hoards in Scotland and the Irish Sea. At 98.3 grams, this arm-ring weighs around four ounces, based on a Viking ounce of c. 24–5 grams. The weights of a number of plain arm-rings seem deliberately to be based on the ounce; such pieces are sometimes referred to as 'ring-money'. Given their crudity compared with other Viking jewellery, it is uncertain how far they were really intended to be worn. Instead they may represent a combination of two different aspects of the Viking economy in precious metal. The giving and receiving of arm-rings was a highly visible aspect of the personal ties between leaders and their followers, providing a clear reward for loyal service, and a symbol of the wealth and power of both giver and recipient. At the same time, silver bullion measured by weight was an important means of exchange throughout the Viking Age. 'Ring-money' combined the symbolic value of the arm-ring with a conveniently measured sum of silver bullion.

Hack-silver and ingots
The remainder of the hoard's contents is silver bullion (Fig. 14). This includes a mixture of ingots of various sizes – some complete, some fragmentary – with an assortment of chopped-up silver ornaments. These fragments, known as 'hack-silver', come from brooches, arm-rings and neck-rings, and it is clear that they had circulated as currency before the hoard was buried, since few if any of the fragments come from the same original items.

The fragments derive from a variety of sources. Some of the pieces are typically Viking, and could have come from anywhere in the Viking world. Other pieces are recognizable as fragments from brooches of types typical of the area around the Irish Sea (Fig. 21). Two pieces, however, have parallels rather further afield. One is from a type of neck-

13 A silver arm-ring
from the Vale of York
Hoard. Diam. 7.1 cm

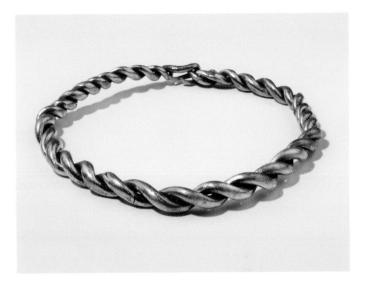

ring made of a single twisted rod with terminals in the shape
of Islamic bronze weights, known as a 'Permian ring' (Fig. 19).
Complete rings of this type were normally produced to set
weights, and are linked to northern Russia. They correspond
with a tenth-century Arab account of Viking traders in
Russia making weight-adjusted neck-rings for their wives
from the coins they obtained from trade with the Arabs.
Complete rings are most common in Russia and around the
Baltic, but fragments like this are widespread, and once
again there is a parallel in the Cuerdale Hoard.

The other piece of particular interest is a hinged brooch
pin, with a chain leading to a bead (see Fig. 14). The brooch
itself is missing, while it is clear from the shape of the bead
that it originally connected to a second chain, leading to
another brooch. The bead appears to be of western
European design, but a parallel to the arrangement of
brooches, bead and chains can be found in the Viking hoard
from Gnezdovo in Russia. Like the Islamic dirhams, the
Russian connections of these pieces serve as a reminder
that, while on one level the hoard represents raiding in
western Europe, on another it demonstrates a system of
trading links that stretched from the North Atlantic to the
Middle East and Central Asia.

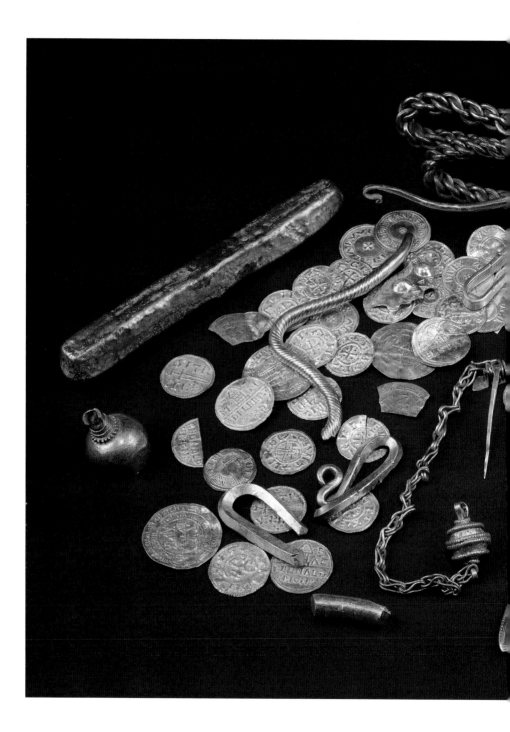

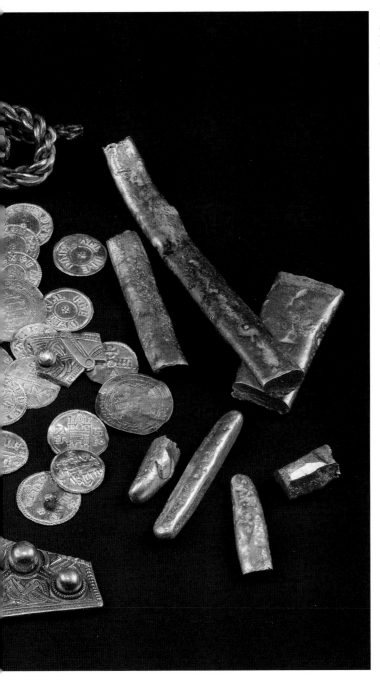

14 Hack-silver, coins and ingots from the Vale of York Hoard. The hinged brooch pin can be seen at centre.

Chapter 3
The hoard in context

The Vikings in Britain and Ireland

The earliest recorded Viking raids date from just before
AD 800. The Northumbrian monastery of Lindisfarne was
sacked in 793 (Fig. 16); around the same time another raid
is recorded in Dorset, while defences against Viking attacks
were ordered in Kent. Raiding in Scotland may have begun
even earlier, since the earliest Viking raids seem to have
come from western Norway, and the most direct route was
across to the Northern Isles of Scotland and down both the
east and west coasts of the British Isles. By the late 790s
Vikings were also raiding in the Irish Sea. Viking raiders
also attacked the Frankish kingdom, in what is now France,
Belgium and the Netherlands.

The early raids were on a small scale, carried out by a
handful of ships, which came, plundered and quickly
disappeared. The same pattern continued in England
throughout the early ninth century, although it is possible
that the Vikings were already beginning to settle in
northern Scotland by this time. By now raiders seem to have

16 Stone carving from
Lindisfarne, showing
men armed with swords
and axes, probably
Viking raiders.

29

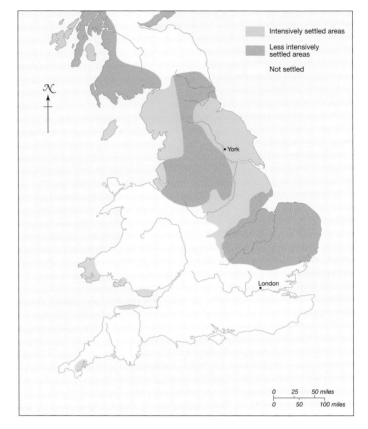

17 *right* Map of Viking settlements.

18 *overleaf* Part of the hoard of Viking silver buried around 905–10 and found at Cuerdale, Lancashire, in 1840. British Museum

Intensively settled areas

Less intensively settled areas

Not settled

N

• York

London

| 0 | 25 | 50 miles |
| 0 | 50 | 100 miles |

come from both Denmark and Norway, although contemporary accounts tend to refer to them all as 'Danes'. However, by the 830s and 840s, both the scale and the nature of the raids were changing. Contemporary records begin to list larger fleets: thirty-five in 836, and others as high as six hundred. These upper figures may be exaggerations, but there is no doubt that the Viking forces now numbered hundreds of men at least. As the forces became larger, they also went in for longer raids. Instead of isolated hit-and-run attacks, they raided whole regions, and it is recorded that instead of going home after a summer of raiding, they would stay over the winter to raid again the following year.

The modern countries of England, Ireland, Scotland and Wales did not exist yet, and the Vikings were attacking

much smaller kingdoms, which often fought each other as well, a fact that the Vikings were able to exploit. From the 860s fleets aimed at conquest, not just short-term raiding, and their forces were large enough to wage war against individual kingdoms. By 880 Viking rulers controlled most of northern and eastern England, and were settling in large enough numbers to leave a permanent record of their stay in the form of Scandinavian place-names. Viking kingdoms were established in Northumbria (with its centre at York; see Fig. 15) and East Anglia, with smaller political units across the Midlands.

Viking success elsewhere was more mixed. By 900 the Northern Isles of Scotland were firmly under Viking control, and they were also settling in coastal areas around the northern and western mainland, and in the Western Isles, although a new unified kingdom of the Scots was also emerging in southern and eastern Scotland. The Isle of Man was also settled by the Vikings, but in Ireland the native kings managed to restrict the Vikings to a small number of coastal settlements, such as Dublin, Waterford and Limerick. These were fortified settlements combined with trading centres, and also formed bases for raids inland and around the Irish Sea. A few Scandinavian place-names are known from around the Welsh coast, but no major settlements are recorded (Fig. 17).

The Viking kingdom of Northumbria thus had access to the Scandinavian homelands and the Continent across the North Sea, and to the Viking settlements in Scotland, Ireland and the Isle of Man via the Irish Sea. At the same time, the bulk of the Anglo-Saxon population probably survived the invasion, and the Northumbrian Vikings also had contact with the Anglo-Saxons to the south.

Viking hoards from northern England

The Vale of York Hoard reflects the range of connections held by Northumbria after the conquest. Like many Viking hoards, it contains a mixture of material from around the Viking world. The Islamic coins and some of the jewellery probably came directly from Scandinavia; the four Frankish coins and the cup came from the Continent, although they

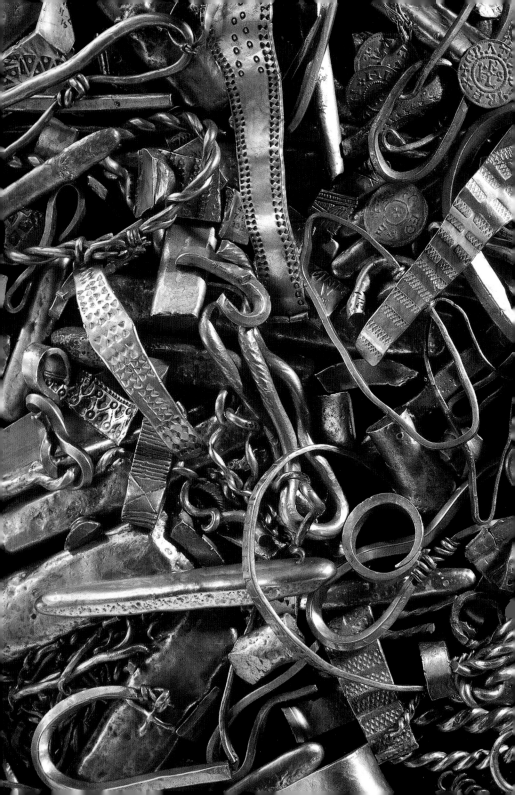

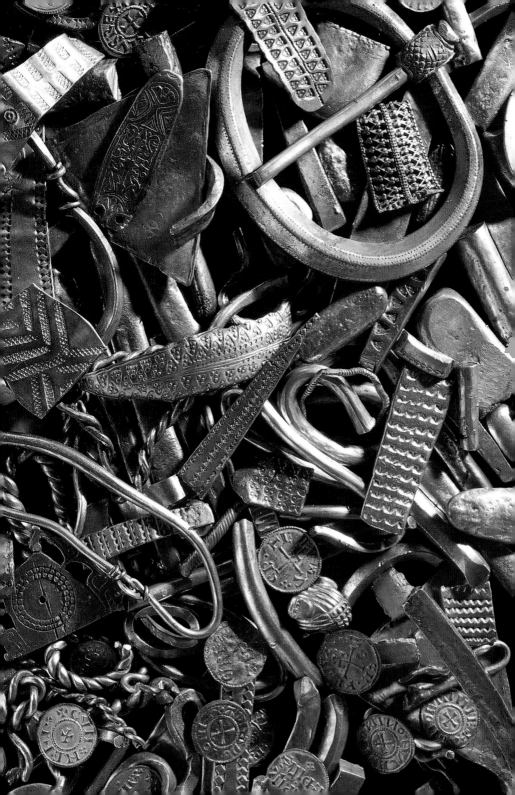

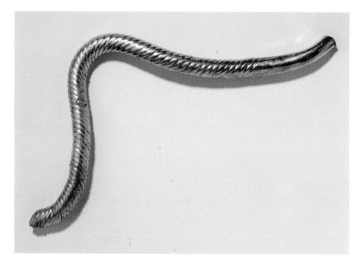

19 Permian ring fragment from the Vale of York Hoard. L. 10.1 cm

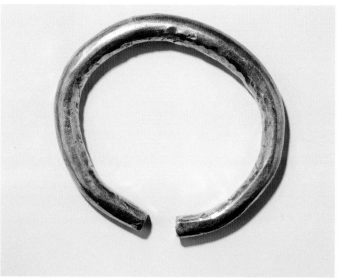

20 A silver arm-ring, known as 'ring-money', from the Vale of York Hoard. Diam 7.4 cm (max)

may well have been in Viking hands for a while by the time the hoard was deposited. Other items of jewellery almost certainly came from Ireland, or at least from the Viking settlements around the North Sea. The bulk of the coins came from southern England, although some were issued by the Vikings themselves, both in York and in various places south of the Humber.

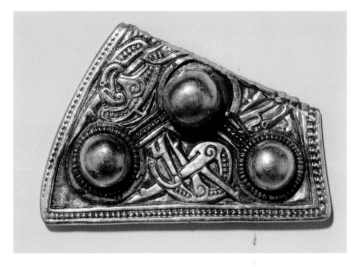

Other hoards from Viking Northumbria show similar
mixtures of material. Seventeen hoards of various sizes are
known from the kingdom between the mid-870s and the
late 920s, although their findspots are fairly widely
dispersed. The largest by far was the one found on the
banks of the River Ribble at Cuerdale in Lancashire, which
contained a total of 40 kilograms of silver, including around
7,500 coins (Fig. 18). However, the Cuerdale Hoard
contained no gold, nor did it contain any single piece as
important as the Vale of York cup. All the others are rather
smaller than the Vale of York Hoard, ranging from a tiny
hoard of six pieces of hack-silver and three Islamic dirhams
from Wharton in Lancashire, to a hoard of over two
hundred coins from Bossall/Flaxton in North Yorkshire.

The contents of the hoards vary. Most, but not all,
included coins, but many of them also included intact
jewellery, hack-silver and ingots. Two contained only pieces
of intact jewellery, while a hoard recently found near
Huxley in Cheshire contained flattened arm-rings
and other bullion, but no coins. The different types of
hoard seem to reflect various economies within Viking
Northumbria and more widely within the Viking world.
The first was based around the display of wealth to show
status. Large brooches, arm-rings and neck-rings were

22 Viking silver pennies of the 920s, in the names of Sihtric, *top*; St Martin of Lincoln, *middle*; and the otherwise unknown mint Rorivacastr, *bottom*

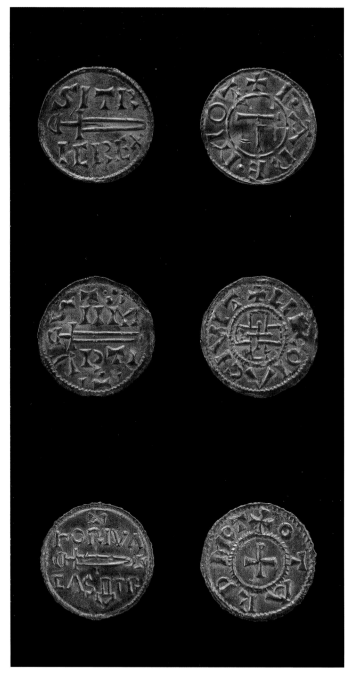

worn as much to show off the wearer's wealth as for any practical purpose. By contrast, precious metal in any form could be used as money within a bullion economy, in which the value of the metal was measured simply by weight. Within this kind of economy silver and gold were used both as a means of exchange and as a store of wealth.

Weights are common finds at Viking sites. The quality of the metal could be tested in different ways, the two most common of which seem to have been bending and cutting into the surface or edge of an object with a knife. Cuts on the edge of an object are referred to by archaeologists as 'nicks' and cuts into the surface as 'pecks'. Bending, nicking and pecking showed two things. First, they made it clear whether or not an object was plated with a thin surface of silver or gold over a base-metal core. Secondly, they showed how hard or soft the metal was. Mixing with lead or copper would alter the hardness of the metal, so anyone familiar with these testing processes relied on being able to recognize the 'feel' of good silver.

Hack-silver and ingots obviously fit into a bullion economy, but jewellery and coins could also be used as bullion. Gold and silver in any form could easily be melted down and turned into something else. The presence of coins in a hoard therefore does not indicate a fully coin-based economy, and most of the coins in the Viking hoards are imported.

However, the Vikings in England did produce coins of their own. Both during the raiding period and then during the settlement period that followed, the Vikings became familiar with Anglo-Saxon customs and gradually adopted many of them, including converting to Christianity. Across medieval Europe there was a strong link between a shared concept of Christian kingship and issuing coinage. On the one hand, coins served as symbols of royal authority and political and religious identity. On the other, they provided a means for rulers to generate wealth through control of prices and taxation. As Viking rulers in England converted to Christianity, they began to produce coins of their own, in East Anglia, the Midlands and Northumbria.

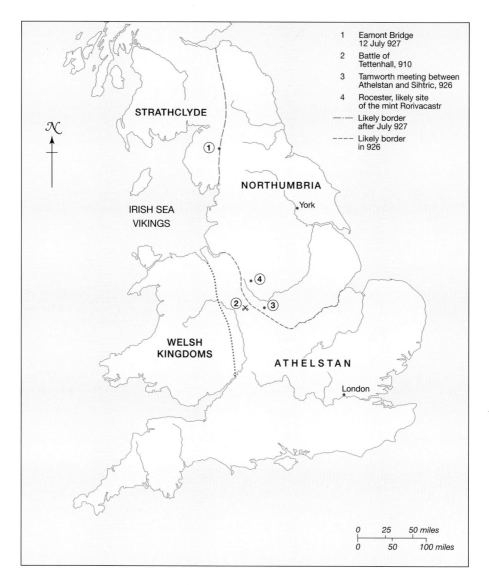

1 Eamont Bridge
 12 July 927

2 Battle of
 Tettenhall, 910

3 Tamworth meeting between
 Athelstan and Sihtric, 926

4 Rocester, likely site
 of the mint Rorivacastr

—·— Likely border
 after July 927

---- Likely border
 in 926

STRATHCLYDE

NORTHUMBRIA

York

IRISH SEA
VIKINGS

WELSH
KINGDOMS

ATHELSTAN

London

0	25	50 miles
0	50	100 miles

In Northumbria, a substantial coinage was produced at
York, probably beginning in the 890s, with coins issued in
the names of the rulers Cnut and Sigeferth. From around
910 the kings' names were replaced by that of St Peter,
the patron saint of York Minster. The St Peter coinage
continued into the 920s, although there were also issues

in the names of Regnald (reigned *c.* 917–21) and Sihtric (r. 921–6; Fig. 22). However, unlike the Anglo-Saxon kings, the Viking rulers of Northumbria had only very limited control over the circulation of coinage and other forms of silver. Anglo-Saxon and Frankish kings of the period were largely able to exclude imported coins from circulation, and to insist that payment was made in their own coins.

By contrast, the hoards suggest that the kings of Northumbria had no such authority. Only two hoards, one from York itself and one from Lancashire, contained only York issues. Most comprise a mixture of local and imported coins, often with hack-silver, ingots and/or jewellery. Archaeologists and historians have sometimes drawn a distinction between the Vikings around York and those in the north-west, the latter being seen as linked more with the Irish Sea than with York. However, there appears to be no real difference as far as the hoards are concerned. York coins appear in a number of hoards from the north-west, while the Vale of York, Goldsborough and Bossall/Flaxton Hoards (all buried within a few miles of York itself) contained both imported coins and other silver objects, including material from the Irish Sea area.

The Vale of York Hoard is thus typical of Viking hoards from the region in many respects, although its size and the quality of some of the objects in it are unusual, as is the fact that it can be dated fairly precisely. It also appears to be the latest in a group of hoards dating from the mid- to late 920s, and the mixture of coins in the hoard means that it has particular significance for our understanding of the political history of the period.

The Vale of York Hoard and the unification of England

24 Silver pennies of Alfred the Great (Winchester) *top*, Athelstan (York) *middle*, and Edgar (Derby) *bottom*, all showing mint signatures. Alfred's coins only mention a few mints, but both Athelstan and Edgar had a national network of mints.

The making of England

The Vale of York Hoard was buried at an important time during the unification of England. In the mid-ninth century there were four main kingdoms, which had swallowed up their smaller neighbours. These were the Anglian kingdoms of Northumbria, Mercia and East Anglia, and the kingdom of the West Saxons. However, when the Vikings turned from raiding to conquest in the 860s and 870s, they conquered and settled in Northumbria and East Anglia, and in the eastern part of Mercia. The last Mercian king, Ceolwulf II, disappears from the historical record around 879, leaving the 'English' part of Mercia under the authority of Alfred the Great, king of the West Saxons (r. 871–99). Alfred's daughter Æthelflæd married Æthelred, a Mercian ealdorman (a high-ranking royal official), who ruled Mercia on Alfred's behalf. Alfred began to style himself king of the Angles and the Saxons, and to promote the idea of a single kingdom of the English, although much of England remained under Viking control throughout his reign. However, the area under Viking rule, known as the Danelaw, was divided into a number of smaller areas under different kings and earls.

Alfred's son Edward the Elder (r. 899–924) began a gradual process of expansion, supported in Mercia by his sister Æthelflæd. Between them they forced one Viking leader after another to submit, gradually gaining control of East Anglia and most, if not all, of Mercia. Some historians have seen this as a 'reconquest' from the Vikings, but these were areas that had never before formed part of the West Saxon kingdom. The expansion continued under Edward's son Athelstan (r. 924–39), who gained control of the kingdom of Northumbria in 927, creating a single English kingdom for the first time. Shortly afterwards, Athelstan met with other kings and princes from around the British Isles at Eamont Bridge in Cumbria (Fig. 25), and they

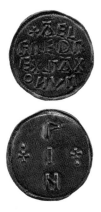

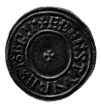

recognized him as some sort of over-king, although this probably meant that they paid him tribute, rather than that he had any direct authority in other kingdoms.

The unification under Athelstan was short-lived. After Athelstan's death in 939 the Viking king of Dublin Olaf Guthfrithsson re-established an independent kingdom of Northumbria, with his power extending into the north Midlands. Although Olaf was killed only two years later, no one ruler was able to establish firm control over the north of England. Several rulers of the Dublin dynasty, which had ruled in Northumbria until 927, competed with Eric Bloodaxe, who had been king in western Norway, and with Athelstan's younger brothers, Edmund (r. 939–46) and Eadred (r. 946–55). Historical sources suggest that many Northumbrians, including the archbishop of York, supported Northumbrian independence under Viking rulers, rather than being merged into a West Saxon empire.

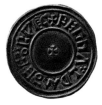

It was only in 954, following the death of Eric Bloodaxe, that West Saxon control was firmly re-established. However, Eadred died the following year, leaving only his young nephews Eadwig and Eadgar to continue the dynasty. Eadwig, who was still only around fifteen years old, did not have the authority to keep the kingdom united, and it was divided in 957 between Eadwig (who kept the West Saxon kingdom) and his brother Eadgar, who became king of Mercia and Northumbria.

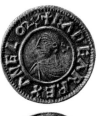

It was only when Eadwig died in 959 that Eadgar re-unified the kingdom once more, promoting the idea of a single kingdom of the 'English'. This allowed for some continuity of local laws and identity, but under the firm royal authority of a single king. We know with hindsight that this time the unification was successful, and the continuous history of England as a single kingdom begins with the reign of Eadgar. However, this must have been less clear-cut at the time, especially in the early years of his reign, and it is important to recognize that Eadgar's achievements were built in part on those of his predecessors.

Of these, Athelstan's success in the 920s is among the most important. The Vale of York Hoard dates from the period in which Athelstan had gained control over

Northumbria, as well as establishing his overlordship over the other British kings. However, the hoard raises some important questions as to how complete Athelstan's authority in Northumbria really was. Contemporary historical accounts of the period provide little more than a framework, and derive largely from royal sources. They therefore present the official story as Athelstan wished it to be remembered, but the hoard provides some additional detail.

The dating of the hoard

It is clear that the hoard was deposited fairly shortly after Athelstan's meeting at Eamont Bridge in 927. This dating evidence comes primarily from the coins. The other material in the hoard is either older (such as the ninth-century cup) or cannot be precisely dated, like the jewellery and bullion, although most of this can be more broadly dated to the late ninth to early tenth centuries. The majority of the coins are also older, dating back to the reigns of Athelstan's father and grandfather. Most of the coins in the name of Edward can be dated to the earlier part of his reign on stylistic grounds, but the hoard contains a significant number of coins from the 920s. These include the various Viking coins and 106 coins in the name of Athelstan himself. These fall into four main groups. The largest group

26 Viking cross shaft from Middleton, Yorkshire. 10th century. The stone shows a typical Viking warrior from the same period as the hoard.

is of the Two-line type of Athelstan, with the inscription ÆÐELSTAN REX around a small cross on one side, and the name of the issuing moneyer on the other. These were issued throughout Athelstan's reign, and do not date the hoard precisely. The same is true of the two coins showing Athelstan's name and title around a stylized bust, derived from a late Roman imperial design.

The other coins of Athelstan are more informative. Thirty-seven of them carry a stylized building, often interpreted as a church. This type was previously quite rare, although it was recorded in the names of several different moneyers. Twenty-two of these coins were issued by the moneyer Regnald, with a clear mint signature of EBORACE, the Latin name of York (Fig. 27). This type is thought to be the first type issued by Athelstan once he gained control of York. However, the hoard also includes a single example of a coin which gives Athelstan the title REX TOTIUS BRITANNIAE, 'King of all Britain' (Fig. 27). This title also appears in some of his charters after Eamont Bridge, and it seems likely that the change in his coinage took place around that time, in late 927 or perhaps in 928. This type then became fairly common, and the fact that there is only one example in such a large hoard suggests that the hoard was deposited fairly shortly (probably only a few months) after the type was introduced, especially since earlier types of the 920s are well represented. The hoard cannot have been buried before 927, but if the REX TOTIUS BRITANNIAE type was introduced in 927–8, then the hoard must have been buried in 927–9 at the latest.

Several of the other recorded Viking hoards appear to date from the mid-920s, and it is likely that the concentration of hoards around this time relates to Athelstan taking control of Northumbria in 926–7, whether they were buried as late as this, or in the years just before. Of these hoards, only the one from Bossall/Flaxton contained coins of Athelstan. Even that contained just two, suggesting that it was deposited very early in the reign, and earlier than the new hoard. The Vale of York Hoard is thus the latest in this group, and dates from a period in which contemporary records suggest that Athelstan was already

27 Silver penny of Athelstan, Building type, AD 926–7, *top*; contemporary Viking imitation of the previous type, *middle*; silver penny of Athelstan as 'King of all Britain', issued after July 927, *bottom*

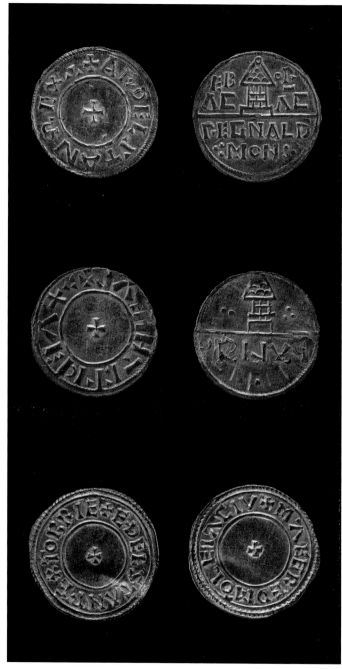

firmly in control in North Yorkshire. This raises the question of who buried the hoard. Its character is certainly Viking rather than Anglo-Saxon, and its size, together with the high value of individual pieces such as the cup and the gold arm-ring, shows that the owner must have been an extremely wealthy man. While the hoard may have been acquired in part through trade, its total value suggests a powerful chieftain. The historical record tells us little about who the important people were in Northumbria after Athelstan took control, but the hoard suggests that at least one important Viking remained in the area for at least a short time, while the burial of the hoard in the period 927–9 suggests that there was continued unrest in the area even after the meeting at Eamont Bridge. Furthermore, the hoard contains a single Viking coin that imitates Athelstan's 'building' type (Fig. 27), indicating that there was still independent Viking minting after Athelstan took control of York.

This picture finds support in a much later account by the twelfth-century historian William of Malmesbury. According to William's account, Guthfrith, the brother of Sihtric, had taken refuge with the Scots as soon as Athelstan first took control of Northumbria, and the meeting at Eamont Bridge was intended at least in part to prevent other kings from supporting Athelstan's enemies. Following that meeting, Guthfrith slipped away, together with an earl Thurferth. He tried unsuccessfully to besiege York, and to persuade the Northumbrians to accept him as king, before being forced to withdraw. We cannot prove a direct connection with Guthfrith or Thurferth, and the scale of the hoard perhaps suggests a less powerful chieftain, but the dating of the hoard certainly fits with Guthfrith's activities.

Whether the hoard's owner was a casualty of these events, or whether some unrelated accident prevented him from recovering the hoard, we will never know. However, his loss then is very much our gain today.

Conclusion

28 The Vale of York Hoard.

The Vale of York Hoard is an important find in many ways. Some of the individual objects stand out in their own right. The cup in particular is both rare and beautiful, and the presence of previously unrecorded coins such as the Rorivacastr sword type and the Viking imitation of Athelstan's building type add to our understanding of the coinage, and to the history of a period with very few written records.

However, it is as a group of material that the hoard is most significant. The objects together create a much fuller picture of the Viking Age than any one object could. Archaeologists and historians have debated whether the Vikings should be seen as raiders or traders. The hoard indicates both activities, with the Islamic coins almost certainly reflecting trade with the Arab world, while the splendid cup was almost certainly removed from a Frankish church or monastery as a result of raiding. To have both in a single hoard reminds us that there is no 'either/or' about raiding and trading. There is no doubt that the Vikings as a group did both, and even the same individual might do both on different occasions.

The range of material in the hoard is also a reminder of the diversity of the Vikings' cultural contacts. The Viking world stretched from Central Asia to the east coast of North America, and the Vale of York Hoard contains objects from many different areas within this. The contents of the hoard represent three different religions – Christianity, Islam and the worship of Thor – and peoples speaking at least five languages. While the Viking period had its share of violence and atrocities, it was also an important period of cultural contact and exchange, so a find like this is important for our understanding of world history, not just that of northern Europe.